"As a painter and an art educator, I found Professor Audette's *The Blank Canvas* to be both compelling and useful. The writer makes no apologies for honoring the history of art. She supports her views with apt quotations from artists and provides many suggestions that art teachers should find useful. She knows more than anyone I know about how to cope with 'creative dry spells,' and her treatment of the artist's studio should impel anyone to view the private work space with a fresh eye. I loved the book and wish it were twice its modest size."

—AL HURWITZ, author of *Gifted and Talented in Art*

"*The Blank Canvas* unlocks, unblocks, and stimulates the creative mind. Anna Held Audette offers a supermarket of ideas from the history of art, presenting the wisdom of—and anecdotes about—artists from centuries past up to the present day. It is comprehensive, honest, and inclusive, offering comments and views both psychological and intellectual, aesthetic and practical."

—AUDREY FLACK, author of *Art and Soul*

The
Blank Canvas

Inviting the Muse

· ·

ANNA HELD AUDETTE

Shambhala
Boston & London

1993

Shambhala Publications, Inc.
Horticultural Hall
300 Massachusetts Avenue
Boston, Massachusetts 02115

9 8 7 6 5 4 3 2 1

First Edition
Printed in the United States of America on acid-free paper ♾
Distributed in the United States by Random House, Inc.,
and in Canada by Random House of Canada Ltd

Library of Congress Cataloging-in-Publication Data

Audette, Anna Held.
The blank canvas/Anna Held Audette.—1st ed.
p. cm.
ISBN 0-87773-938-2
1. Artists' block. 2. Creation (Literary, artistic, etc.)
3. Artists—Psychology. I. Title.
N71.A93 1993 93-9524
700'.1'9—dc20 CIP

To
J.S.H.
and
L.G.A.

On a clear autumn day I was sitting on a bench in the center of Piazza Santa Croce in Florence. It was not the first time I had seen this square, of course. I had just recovered from a long and painful intestinal disorder and hence was in a state of morbid sensitivity. It seemed to me that everything around me was recuperating as well, even the marble of the buildings and the fountain. The Dante monument rose up in the middle of the square . . . suddenly I had the strange impression that I was seeing these things for the first time. The composition of a painting appeared all at once before my mind's eye. Every time I look at that painting now, I see that moment again. What happened back then I cannot explain; it remains a mystery.

—GIORGIO DE CHIRICO

The art of pictorial creation is indeed so complicated—it is so astronomical in its possibilities of relation and combination that it would require an act of superhuman concentration to explain the final realization. Such an awareness is usually absent in the artist. He will never be able to explain the full process which led to his creations. —HANS HOFMANN

CONTENTS

Introduction

Seeing depends on knowledge
And knowledge, of course, on your college
But when you are erudite and wise
What matters is, to use your eyes.
 —ERNST GOMBRICH[1]

Every art student will, at some point, be faced with a blank piece of paper, an empty canvas, or a lump of clay and must respond to the daunting question, "What shall I do?" Suddenly the teacher's supportive, descriptive pictorial assignments have stopped. There is no instructor to give the subject or framework of what must be done, leaving just the specifics to be filled in.

At first it seems as though the longed-for moment has come when you are finally free to do your own work. How quickly the joy of this prospect turns into frustration and even despair as it becomes apparent that the index file in your vast imagination contains only a few cards with boring, worn-out ideas or, worse yet, blanks. At the same time, limitless choices are overwhelming; it's impossible to know where to begin. Art teachers often

say there is nothing more inhibiting than an empty canvas. This situation is not quite the same as writer's block, which is mostly caused by an overly critical internal editor. Artists are also afflicted by their private censors, but if only the initial idea or direction could be found, the beastly critic within would make way for them to grow, a job that is largely hard work. How to deal with these moments (which, by the way, may be recurrent) is the subject of this book.

It is written for beginning artists and art students when they start to realize that they must fly on their own but can't guess how to accomplish that miracle. The ideas, suggestions, and conclusions contained here have come out of many years of college teaching. I've touched on the problems of choosing subject matter with virtually every student I've taught, sometimes briefly, sometimes in great depth and repeatedly. The visual consequences of our conversations have contributed in turn to my thinking about these questions.

In the end, all the discussions about how to develop ideas have revolved around the critical issue of what makes an artist, what accounts for special insights or personal visions. Yet if one approaches this question in such general terms, it becomes too enormous to deal with. This small volume will therefore be concerned with

simple steps and concepts. While it will not provide you with specific answers, it will equip you to deal in a conscious way with some of the essential questions about how to get started on your own. I hope you will also find it supportive and encouraging.

Many professional writers have written extensively about the problem of getting started. This is only natural, given their chosen mode of expression. Artists cannot make images that explain the origins of their ideas, at least not in a didactic way. (Art historians may speak about the sources of an artist's work, but the practical manner in which these sources led to an image, made perhaps hundreds of years ago under very different social and artistic conditions, may not be evident to a student today.)

Much of what I have to say is based on a representational approach to imagery because most students seem more comfortable initially with tangible rather than abstract forms. It's easier to talk about the qualities of an egg than about a hard, ovoid mass. As the verbal exchanges with my own students proceed along with their work, abstract concepts and images are likely to emerge, so from time to time I shall also mention abstract issues.

Wherever possible, I've tried to talk about ideas in terms of drawing because it's the medium shared by most

artists. I've also attempted to make my examples widely representative, and so I regret that the individual artists referred to or quoted are preponderantly male painters. There simply is more information about them. Those who are printmakers, sculptors, or devoted to other art forms will, I hope, be able to adapt or translate these ideas to your own medium. Although contemporary art includes a great many new forms of expression, such as performance and installation art, I've intentionally limited my references to the traditional media taught in colleges and art schools.

In my references to artists, I've generally stayed with established masters simply because we cannot be certain whether the great lights in today's artistic firmament will turn out to be planets or shooting stars. I also realize that my readers' level of experience is variable, and therefore my comments will not always be equally appropriate to all. So here, too, I ask for your accommodation.

And, finally, at the risk of sounding too apologetic, I've intentionally erred on the side of simplicity in talking about a subject that is not quite so tidy or so amenable to explanation. I'm assuming that you need easy access to immediate help, and that is what I shall try to provide. Later on, if you wish, you can explore on your own the more complex aspects of deciding what to do.

Introduction

TO "KNOCK ON SILENCE"[2]

I have not worked at all. . . . Nothing seems worth putting down—I seem to have nothing to say—It appalls me but that is the way it is. —GEORGIA O'KEEFFE[3]

Just dash something down if you see a blank canvas staring at you with a certain imbecility. You do not know how paralyzing it is, that staring of a blank canvas which says to the painter: You don't know anything. . . . —VINCENT VAN GOGH[4]

. . . and I thought, enough of this, I'm not an abstract painter, what the hell am I going to do? Should I get a job in a shoe store, sell real estate, or what? I was really depressed by the whole thing, because I felt like a painter, yet I couldn't make paintings. —RALPH GOINGS[5]

As the artists quoted above so vividly attest, discovering that you have no creative ideas is a devastating experience. It calls into question some fundamental issues about who you really are. Perhaps you are not the creative person you thought you were—after all, here's the terrible immutable evidence. Maybe you're a fraud. Between your inability to make anything and your doubts about whether you've got "the right stuff," you're caught in a vicious circle.

Well, there's no quick fix, no sure way to order up the flash of inspiration. What you can do, however, is create

a set of circumstances that will increase the likelihood of its happening. They are, by and large, quite straightforward, apparently hardly worthy of being parents to a moment of revelation. Yet if you think about it, you'll realize that the building foundations of even the most dynamic architecture are not very exciting. They make possible, but do not foretell, the imaginative structure to come. What follows are some discussions of (to put it another way) things you can do to load your creative dice.

I would like to suggest that you read this book with a pencil in hand and make notes whenever a thought occurs to you. Your creative processes are possibly so elusive at this point that if you don't record your ideas at the moment they happen, they may very well escape.

·I·
Art from Art

Not one great mind coming after them [great artists] but owes them tribute, and finds in them the prototype of his own inspiration. —EUGENE DELACROIX[1]

All the past up to a moment ago is your legacy. You have a right to it. —ROBERT HENRI[2]

My parents were every artist before me whose work I knew. —DAVID SMITH[3]

At various times throughout this century, there have been artists who denied their cultural heritage as a source for their images. They were convinced that art from the past did not contribute to their aesthetic outlook and was generally irrelevant. To feel that one is pioneering in totally uncharted territory is obviously an exciting experience. What we must remember, however, is that veteran explorers carry ample supplies to see them through the rigors of the journey ahead. The history of art contributes to artists in very much the same way. Many more artists would agree with the writer Natalie Goldberg, who felt, "We are very arrogant to think we alone have a totally original mind. We are carried on the backs of all writers

7

[read artists] who came before us. We live in the present with all the history, ideas, and soda pop of this time. It all gets mixed up in our writing [art]."[4]

One of the many things we learn from the history of art (by which I mean everything from prehistoric times to last week) is that artists tend to see things as much or more in terms of other art than through personal observation. Perhaps the best-known illustration of this phenomenon is Cézanne's statement that he wanted to "redo Poussin from nature." Jerry Uelsmann, in talking about his photographs, acknowledged "if you want to know how a little of Minor caught my heart, or a little Callahan caught my eye, or Sommer caught my mind, it's all there."[5] The art historian Leo Steinberg summed up this process when he said, "All art is infested by other art."[6]

Initially this might strike you as an oppressive idea. While it may appear to threaten your individuality and restrict your inquiry, an objective look at the roles played by artists of the past in the creative lives of artists who succeeded them should put your fears to rest. Even more important is that your thinking will be guided by first-rate reference material. While you may use popular or mundane subjects, you should treat them with the inventiveness you've observed in great art and not the hackneyed responses provided by typical commercial sources.

We usually expect young writers to be acquainted with great literature and beginning composers to have a background in music. It's no different for artists. You may perhaps be more comfortable with the idea of the past as something that is not really over but is an exciting feature of the present. In this spirit, I hope you will come to see the history of art as a supermarket of ideas from which you can check out a tremendous assortment of items for your own visual nourishment.

There are artists who reject art history simply because they see it as the domain of art historians. They have taken Art History courses, only to find themselves exasperated by the lectures because the teacher's emphasis seemed to overlook what the artists saw as the most exciting discoveries. Artists' idiosyncratic approaches often result in their making value judgments that would be entirely inappropriate coming from a professional art historian. For example, Thomas Eakins said of Rubens that he was "the nastiest most vulgar noisy painter that ever lived."[7] While artists may not subscribe to the canons of Art History, art historians for their part are sometimes frustrated by the apparent failure of artists to appreciate the logic of their discipline. These misunderstandings are based on two totally different approaches to the same body of information. Art historians are concerned with

orderly, objective description; they study the sequence, context, and meaning of works of art, given the nature of the artist and the times. (Even if you are not entirely in sympathy with the teaching of Art History, I hope you will recognize that its focus is legitimate, albeit somewhat different from yours.)

On the other hand, artists may operate without regard for external classification and, as demonstrated by Eakins, independently of established values. No professional imperative forces them to look at each item in an exhibition or revere all great artists. I remember very clearly how relieved I felt when I became aware many years ago that, as an artist, I didn't have to look at every piece in a show, as I had been taught to do in Art History courses. Later I became comfortable being able to say openly that Cézanne, who was extolled as the greatest of artists in my studio classes, is not in my personal pantheon of painters.

Artists make subjective, intuitive associations and choices according to their own visual responses. Romanesque (Christian) artists took motifs from Sanskrit (Buddhist) calligraphy without knowing what they meant. The many artists in the first half of this century for whom African and other "primitive" sculpture played a significant role were ignorant of the cultural meaning of

the pieces that inspired them. (See fig. 1.) Most art historians would agree that Byzantine art disappeared in the fifteenth century. But Wayne Thiebaud looks at "slot machines, cigar boxes, windows of ribbon shops and dime stores" and sees them as "the last refuge of the Byzantine tradition—all those reds and golds and so on."[8] Thiebaud observes a certain relationship between formal values that elicits a response in him similar to that evoked by Byzantine art. You might say he has done a visual override of established categories. This phenomenon was recognized many years ago by the art historian Meyer Schapiro when he wrote about abstract art, "The new styles accustomed painters to the vision of color and shapes as distinguished from objects and created an immense confraternity of works of art cutting across the barriers of time and place."[9] These observations permit us to reach the optimistic conclusion that, while the immediate and direct developments in the history of art are defined and described, there is also a continuing spinoff that cannot be precisely monitored but nevertheless nourishes all future generations of artists.

The contributions to artists by art that has preceded them are endless. The history of art has provided a vast reservoir of ideas. Not having access to this resource leaves you aesthetically impoverished. Looking at what

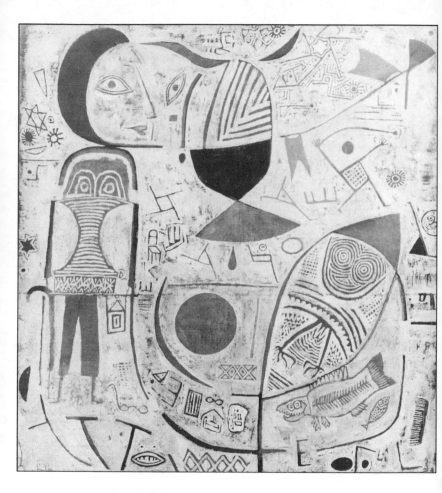

FIGURE 1. Paul Klee, *Picture Album*, 1937. Gouache on canvas.
© The Phillips Collection, Washington, D.C.

artists have done before us confirms the existence of an infinite wealth of possibilities for aesthetic expression. It tells us that each century produces new ideas, and by extension, ours and those to follow are certain to do the same. It also makes clear that artists cannot escape their own times. Looking back, we can easily see the difference between the sensibilities of one century and those of another. The ultimate weakness of most artistic fakes rests on the inability of forgers to stylistically transcend their own moment in history.

A more positive view of this phenomenon suggests that it's impossible not to be of one's times, at least in a general sense. You are guaranteed by birth to be contemporary. Of course, at any given period, there are some revolutionary artists storming the so-called barricades while others work more quietly on the home front. What we learn, from the advantage of hindsight, is that there are always fine artists of both temperaments. A comprehensive assessment of American art during the middle decades of our own century would surely document major aesthetic upheavals, but it would also have to include independent artists such as Edward Hopper, Fairfield Porter, Ben Shahn, Isabel Bishop, and Joseph Cornell.

By observing the tides of art movements over past

centuries and recent decades, you'll have a better aware-
ness of the fleeting character of fashionable ideological
dogma. It's much easier to consider contemporary mani-
festos critically when you have some historical perspec-
tive to give them a context. It's a good idea to follow
contemporary art criticism intellectually but not neces-
sarily in your own work. As Robert Henri said, "Art
appreciation, like love, cannot be done by proxy."[10]
Wassily Kandinsky made a comment that is similar, if a
bit more opinionated. "The artist must be blind to dis-
tinctions between 'recognized' and 'unrecognized' con-
ventions of form, deaf to the transitory teaching and
demands of his particular age. He must watch only the
trend of the inner need, and hearken to its words alone."[11]

Another good reason for being acquainted with art of
the past is that it allows you to "meet" an immense
number of artists with whom you share something in
common. You are not as alone as you may have felt.
Probably you'll establish a feeling of kinship with at least
a few of them. Their accomplishments may teach you or
confirm what is happening in your own work. It's elating
and instructive to discover that your vision resonates in
sympathy with that of other artists, sometimes over a
distance of centuries. Not to have this opportunity would
be to deprive yourself of a major source of inspiration.

FIGURE 2. Pat Steir, *The Tree after Hiroshige*, 1984. Aquatint, etching, and drypoint. Crown Point Press, San Francisco.

At the same time, don't think that your images should necessarily look anything like those made by your favorite masters. We don't pick our friends because they resemble us, and the same could be said about our relationship to the artists we admire.

The ways in which artists use art from the past vary greatly. Frequently ideas are absorbed in an unconscious manner or the sources have been so transformed that they are barely discernible. Looking at some of Pat Steir's images, you may not immediately realize her deep sense of connection with past artists such as Hiroshige (see fig. 2), Rembrandt, and Brueghel. The evidence is slightly more perceptible in Charles Hawthorne's portraits, such as the *Three Women of Provincetown* (fig. 3), with their distant nod to seventeenth-century predecessors.

At the other end of the spectrum are those artists who make overt use of prior art forms and want the viewer to be aware of the reinterpretation. The results of these creative transformations of existing images are like themes and variations in classical music or the improvisational developments of jazz. As one might well imagine, the longest list of appropriated artists belongs to Picasso. Some of the famous artists whose works he "adopted" were Velasquez, Murillo, Rembrandt, Delacroix, Manet, and Degas. He also looked at lesser-known

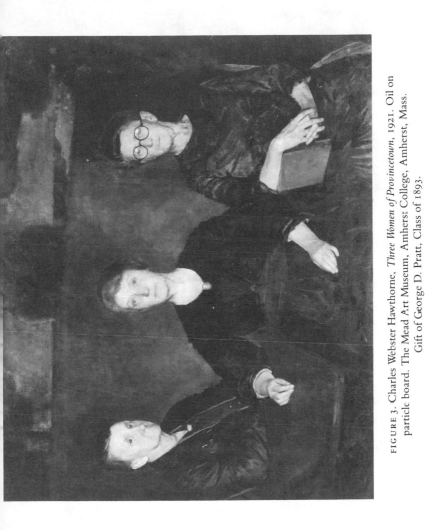

FIGURE 3. Charles Webster Hawthorne, *Three Women of Provincetown*, 1921. Oil on particle board. The Mead Art Museum, Amherst College, Amherst, Mass. Gift of George D. Pratt, Class of 1893.

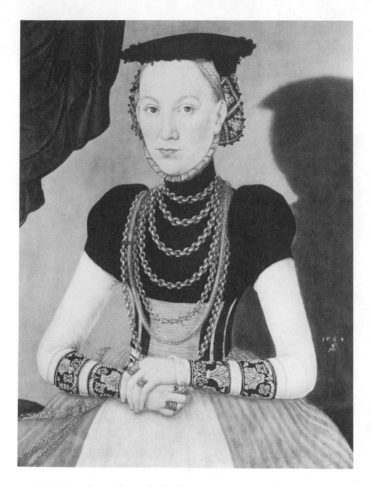

FIGURE 4. Lucas Cranach the Younger, *Portrait of a Woman*, 1564.
Oil on canvas. Kunsthistorisches Museum, Vienna.

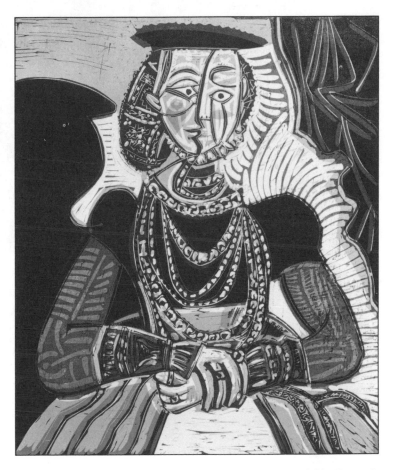

FIGURE 5. Pablo Picasso, *Portrait of a Woman, after Lucas Cranach* [the Younger], 1958. Linoleum cut. The Metropolitan Museum of Art, The Mr. and Mrs. Charles Kramer Collection, Gift of Mr. and Mrs. Charles Kramer, 1985 (1985.1079.1).

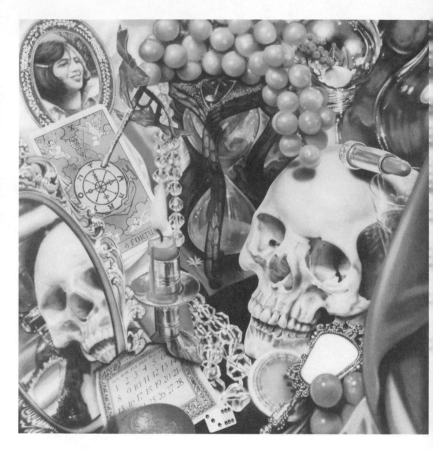

FIGURE 6. Audrey Flack, *Wheel of Fortune (Vanitas)*, 1977–78. Oil over acrylic on canvas. Courtesy Louis K. Meisel Gallery, New York. Photo: Bruce C. Jones.

paintings, such as the *Portrait of a Lady* (fig. 4) by the sixteenth-century artist Lucas Cranach the Younger, which he redid as a linocut (fig. 5). Larry Rivers is known for his reworking of images by Rembrandt, David, and Manet. Audrey Flack found that the theme of *vanitas* (the transitory nature of earthly life), which found great favor in seventeenth-century art, was for her equally compelling today. She translated the idea into a twentieth-century idiom because it spoke to her vision of our own times (fig. 6). Artists as diverse as Leonard Baskin and James Rosenquist have acknowledged their debt even more openly, with pieces inscribed with the name of an artist who nurtured them.

Your training has doubtless given you some of the visual language of art. What is not so obvious (but hardly less important) is that it's very helpful to be able to talk about it. Language permits you to describe what you are doing. The history of art gives you a great reference vocabulary. If someone says that your sculpture is reminiscent of works by David Smith, a very exact comparison will appear in your mind. The usefulness of this book is enhanced by the level of your capacity to associate images with the artists mentioned. It's also important for you to be able to talk about your work with people who are on the same artistic wavelength. Having friends and/

or teachers with whom you can trade ideas and who can give you critical comments (not just compliments) is essential to your development. You get so close to, and so wound up in, what you are trying to do that you can lose perspective. Your mind may trick you into seeing what you want to see, not what is really there.

Being able to speak about your work in an intelligent way not only helps you to communicate with other artists, it also—and this is what matters most—increases your ability to communicate fully with yourself. You need this basic tool for knowing and comprehending, so that you can explore further. People who have learned to identify, say, trees in the woods realize that knowing these names has sharpened their powers of observation, and consequently their understanding of the forest has deepened. The sculptor Anne Truitt wrote: "The shape of my work's development becomes a little clearer every time I am forced to articulate it."[12]

·2·
Other Popular Sources

PHOTOGRAPHS

Artists have used photography since about 1840: that is, almost from the time of its invention. As a way in which we obtain visual information, photographs are second only to direct observation. On some level, every artist is informed by photographs.

As soon as the first photographs (often influenced by painting) became available, artists saw how useful they could be. The automatic translation of a subject into a two-dimensional image was only the first advantage. Photography helped increase the understanding of human action enormously, well beyond what could be learned from poses struck by studio models. It played a major role, naturally, in portraiture. Van Gogh wrote that he had "tried to draw a few portraits after photographs and I think this is a good practice."[1] Photography helped artists to envision people or scenes that could not be recorded in either the time or the place needed to make an adequate drawing. You will get a sense of this if you question where artists were when they created a

certain image, how they managed to observe a momentary event, or by what means they knew how to picture places they had never been to. Manet never was in Mexico for the event in his print *The Execution of Maximillian* (Fig. 7) and the depiction of the soldiers and setting was determined by artistic choice. But the representation of the main subject, the victims, was influenced by photographic portraits. Gauguin used photographs of Java, Egypt, and ancient Greece, and Degas (an amateur photographer himself) studied the stop-action photographs made by Eadweard Muybridge in the 1870s to understand how horses' legs really move.

In this century, artists have become particularly aware of the special visual effects that photography can create. From the very beginning, artists noticed the fuzzy areas resulting from different focal settings and the ambiguity of spatial depth. These characteristics typically show up in blurred backgrounds and a compressed sense of distance. The seemingly random relationships between forms, odd juxtapositions, exaggerated foreshortening, peculiar colors, and strange angles found in photographs were seized early on. The curious composition in Degas's *Place de la Concorde* of about 1875 (fig. 8), with its singular spatial relationships, is unimaginable without the existence of the camera. As quickly as photographers

24

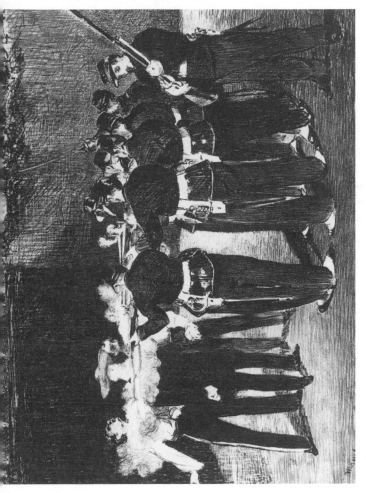

FIGURE 7. Edouard Manet, *Execution of Maximillian*, 1867, printed 1884. Lithograph.
S. P. Avery Collection, Miriam and Ira D. Wallach Division of Art, Prints and Photographs,
The New York Public Library, Astor, Lenox and Tilden Foundations.

made technical and visual advances, artists took the results for their own use. Marcel Duchamp's *Nude Descending a Staircase* is derived in part from a multiple-exposure photograph.

A few artists, such as Charles Sheeler and Man Ray, were also professional photographers, but most artists who take their own photos use them as a note-taking device without much concern for the ultimate quality of the photograph as an image in its own right. Pat Steir doesn't even use her many photographs in her painting directly. She just feels that they help her in a general way to see differently. In quite another manner, the photorealists saw differently too. They made paintings quite literally of photographs, emphasizing the explicit nature of a single moment captured by the camera's shutter. Photography not only has been important to individual artists, but has also played a pivotal role in the overall development of art in the twentieth century. Collage would never have assumed the importance it has in this century without photography, and at least three major modern art movements—surrealism, pop, and photorealism—are indebted to or based on photographs.

Photographs have also become tremendously important, if not the primary, sources of information about other art. (For some art, such as earthworks that must be

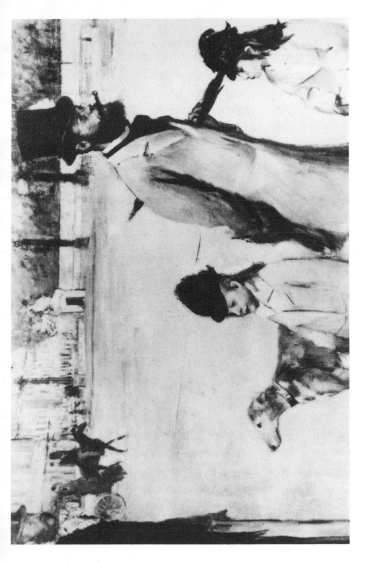

FIGURE 8. Edgar Degas, *Place de la Concorde*, c. 1875. Oil on canvas.

seen from the air, photographs are practically the only means for seeing them.) Although there is no substitute for viewing an original work of art, just as recordings will never provide the richer and more vivid experience of a live concert, the chances are that when artists refer to other art, they are actually talking about a photographic reproduction. Likewise, photographs have become our primary means of access to the natural world. Virtually everything we know about our planet, beyond what we see directly, from satellite views to miscroscopic revelations, we have learned through photographs. Movies, television, and video have also changed the way we see. Computer technology may make the most significant new contribution to our visual resources, one that is likely to rival the impact of photography.

We should, of course, also take into account what photographs cannot do. They don't capture everything the human eye sees. Typically, they lose information in shadow areas. Only the most sophisticated processes record anything like the color range human beings perceive, and photographic images sometimes contain visual distortions. If you use photos, these distortions can creep imperceptibly into your work, because we have an automatic tendency not to question these pictures. (There are of course some artists who use distortions consciously.)

Photographs can't be a substitute for drawing, because drawing develops your own response to things that you see. With their apparent authority, they may also influence you to override your own expression. It's very hard to argue with the "truth" provided by a photograph. Yet to say that "the camera never lies" is a lie itself. On another level, when they are seen out of context, photographs may fail to convey their real meaning. The two best-known photographs from the Vietnam War, *Accidental Napalm Attack* showing a fleeing naked child and *Guerrilla Dies* depicting a point-blank military execution, could be misinterpreted and/or lose much of their impact if we didn't know their background.

COPYING

> *I've been fifty thousand times to the Louvre. I have copied everything in drawing, trying to understand.*
> —ALBERTO GIACOMETTI[2]

> *One always begins by imitating.*
> —EUGÈNE DELACROIX[3]

Students are sometimes told, in their first art courses, that they shouldn't copy, because it will prevent them from being original. This is poor advice, based on the false assumption that imitation stunts creativity. In actual fact, imitation may be a significant part of the quest to

discover your own voice, and dismissing this activity could deprive you of a surprisingly valuable experience.

There is overwhelming evidence that copying (and I shall use the term loosely to cover everything from the most accurate renderings to the loosest interpretations) has been an important resource for innumerable artists. The art of visual "stealing" from other artists has a long pedigree. Consider, for example, the following "genealogy": Michelangelo copied Masaccio, Rubens copied Michelangelo, Delacroix copied Rubens, Matisse copied Delacroix, and Lichtenstein copied Matisse. Sometimes even the copier may be copied in turn, as in the following story related by Jacques Lipchitz.

> I remember one day when Juan Gris told me about a bunch of grapes he had seen in a painting by Picasso. The next day these grapes appeared in a painting by Gris, this time in a bowl; and the day after, the bowl appeared in a painting by Picasso.[4]

Artists copy for many reasons. The principal one is to learn. From the early Renaissance until recent times, copying constituted the initial experience in an artist's training. Students were set to imitating masters and drawing from plaster casts of classical sculpture. (Leon Battista Alberti, in his 1432 treatise *On Painting*, made the gentle suggestion that students might "prefer to copy the

works of others, because they have more patience with you than living things.")[5] Only after copying casts were they allowed to draw from a live model. Before the discovery of photography, books of hand-engraved copies (fairly faithful reproductions) were made to instruct younger artists. One such book was made by engravers who based their work on drawings by Van Dyck after Rubens.

Historically, various aspirations and some very practical problems were resolved through copying. By borrowing from old masters, artists could imply that their work was a link in the great chain of descendants from the art of antiquity. Visual references to a previous master's work could also serve as a way of honoring that artist. Occasionally artists were commissioned to paint a second version of one of their own works. Chardin actually made at least three copies of his painting *Boy Blowing Bubbles* to satisfy several clients. Goya did a series of prints after Velasquez as part of a publication intended to make the contents of the Escorial better known in Europe. While the figures in this series are quite faithful to the Velasquez originals, the backgrounds have been greatly simplified in character with Goya's own work.

The practice has continued to the present day. Van Gogh wrote, "It interests me enormously to make copies.

. . . I started it by chance and I find it teaches me things."[6] Early in his career, Jackson Pollock made many studies of works by Michelangelo, Brueghel, Rubens, and especially El Greco. Recently, Wayne Thiebaud remarked, "If I don't have anything better to do that day, I'll copy paintings, generally by people who have some relationship to the work of the moment."[7]

Copying can, of course, have a negative outcome, as when it becomes an end in itself and not a means to obtain information for later use. The point is also lost if the subject being copied is not a significant work of art, since you can only learn from the best examples. Poets don't waste their time emulating greeting card verse. It's true that artists have occasionally copied individual figures or motifs as labor-saving devices or used them to compensate for lack of invention. When this kind of copying is used as a substitute for personal expression and its true nature is unacknowledged, the experience is at the very least sterile and perhaps deceitful. When, however, imitation is used critically and selectively as nourishment for the creative process, it can be a powerful stimulus to an artist's inventiveness.

FINDING AND USING SOURCES

Having talked so much about how other art contributes to your creative processes, I must now add that it's vital

for you to see works of art "in person." Take advantage of those most important resources, your local museums and galleries. You can't get the real sense of a work from a reproduction any more than you can know a person from a photograph. For instance, one of the most frequent and striking discoveries students make is that the original work is much smaller or larger than they supposed.

As someone who is trying to make art too, you want to get near enough to see how the artist did it. You connect with the art and the artist in a special way when you are close enough to "see the hair from Cezanne's brush."[8] Above all, you need to have the unique feeling of being surrounded by the work of a particular artist, which is often a wonderfully energizing experience. You may also have the remarkable, though brief, sensation of seeing everything immediately outside of the exhibition through the eyes of the artist you just looked at. Most artists remember certain experiences in galleries and museums as having had a major impact on their formative years. Fairfield Porter recalled:

> When I was twelve, I was taken to the Chicago Art Institute by my mother, and I remember I always liked to see the paintings. Among the paintings I remember in the Institute [was] Giovanni di Paolo's

Beheading of John the Baptist, which was sort of fascinatingly gory. And Rockwell Kent I liked very much. And about that time, when I was twelve or thirteen, an exhibition of Pablo Picasso, the Egyptian period, those great big heads. That impressed me very much. I thought if this is what painting is, it's a significant activity.[9]

At the beginning of this chapter, I suggested that an artist should know the full span of art history, including works created as recently as last week. You are probably very up to date on the latest movies and music, but are you equally in touch with what artists are doing this year? In the entire history of art, artists have probably never expressed themselves in such a variety of ways as we now encounter, nor have their works been so available. Of course, the most accessible sources of information about current developments are galleries, books, and art magazines. You need not only to look at what contemporary artists are doing but also to read what they have to say and what is written about them. Ideas and theories (such as minimalism and postmodernism) have played a very important role in art of the last half century, and you owe it to yourself to know something about them.

Now, it may seem that I've given you so much research to do that you'll never get around to making art. Well, the situation isn't that bad. Pick and choose among these

resources. It's like going to the library. You can't read all the books, so you go after what looks appealing. Gradually you'll branch out. An article you've read will make you want to see an exhibition, or an artist's work will encourage you to read about other artists in the same movement. Your college or university will give you a start as an artist, but actually you'll have to accomplish most of your own education. Your needs are so singular and individual that no institutional program can provide all the answers. Artists educate themselves all their lives, in the direction and to the extent that their art requires, by doing the things I've mentioned.

·3·
Working

The Studio

You can't make art unless you have a place in which to make it. Evident as that may seem, I'm surprised by how often students fail to fully recognize this need. If you don't have a room to yourself (in effect a studio), you must, at a very minimum, have some place that belongs to you alone. Be selfish. You should feel entitled to a space. The availability of your area cannot be dependent on when the table is not used for meals. In order to be able to work whenever necessary, you shouldn't have to clean up and clear out for any reason. (Hokusai, who moved at least once every year of his long life, is said to have preferred relocating to having his work interrupted by house cleaning.) Your space must be one that won't be disturbed, so that you can maintain as much continuity as possible with where you left off. You also need to be able to surround yourself with things you have made, to remind yourself of what you have accomplished or failed to do, and to make note of what you should work on.

Working

A room of one's own is perhaps even more important for your mindset than for practical reasons. It's a place for you to grow and develop, a haven and a sanctuary. In the beginning there are many challenges to your conviction about becoming an artist. The establishment of your own space is a crucial step in affirming the direction you are taking and convincing those around you of the seriousness of your pursuit. Unfortunately, women seem to be especially prone to compromises on this issue, failing to realize that they are giving up much more than space. Even when their partners are artists who should understand this fundamental need, women often find themselves making do with the lesser work area of the two.

Let's assume you've been fortunate and you do have a studio. Images projected by the media of what a Real Artist's Studio looks like (an industrial urban space with lots of work standing around in various states of completion, pots of paint in front of them, and a general look of disarray)[1] are misleading. Artists work in all kinds of places: several rooms together, the upper stories of their houses, barns, garages, and, of course, converted commercial spaces. Old factory buildings often have the advantage of housing other artists who may be very helpful to your work. Some artists prefer a space at home; others require an entirely separate workplace. Romare Bearden

stopped living in his studio because "you're always jumping up at night; you want to paint, and you start wrecking things."[2] There are artists who work in clutter accumulated over years; others clean up after themselves daily. Most fall somewhere in between.

You'll be finding out about your work habits, which are as different among artists as lifestyles in the public at large. While most artists work largely during the day, a few, like Philip Guston, paint only at night. Obviously, having northern light is not essential to these people— but plenty of painters who work during the day don't insist on it either. (I can't remember seeing a gallery with northern light.) Robert Motherwell often worked on the floor (as Rauschenberg does and Dubuffet did), to keep his paint from dripping and so that he could walk around his paintings. There are artists who find they work better at certain seasons of the year. Knowing that one is in an "off" season will temper excessive self-criticism during a difficult time. Many artists don't have a phone in their studios (or have an unlisted number), and some won't permit visitors, even their friends. What they all want is a place as free of outside intrusions as possible.

Wear comfortable old clothes that can get dirty or dusty—there is no such thing as looking like an artist. (This seems obvious, yet I'm always amazed by how

often students forget that making art is, among other things, pure manual labor.) Many artists listen to music as they work—one I know of *listens* to television. Another talks to his paintings.

You need to arrange your studio environment so that it fits you. Even Van Gogh, who was forced to work under the most rudimentary conditions, wrote, "I have taken some [prints] for my little room to give it the right atmosphere, for that is necessary to get new thoughts and new ideas."[3] It is illuminating in this context to hear Gauguin's reaction to the town Van Gogh found so congenial: "I am at Arles quite out of my element, so petty and shabby do I find the scenery and the people."[4] Clearly the two artists had quite different ideas about what constituted the right environment.

Artists tend to collect images that have caught their attention. They acquire books, magazines, other art, and "things." They save clippings, postcards, gallery announcements, and photographs, but most of all, they keep sketchbooks. Many, like Claes Oldenburg, carry them around all the time. These books are used differently by each artist: for making sketches, preserving important items, taking notes on exhibitions, and often for writing. For some people, writing about observations, reactions, and perhaps dreams clarifies their think-

ing. Sketchbooks may be used to draw from a model, to record visual impressions of a trip, or for marks that don't mean anything to anyone but their maker. In these, and many other ways, artists build up a rich source of visual references. They are a good insurance policy against getting stuck. A friend of mine never opens his sketchbook to a blank page. He looks at filled pages first, as a source of regeneration, much the way one would look at a previous day's writing.

The long and the short of the matter is you need to be in an environment that's conducive to working. As you'll see in the next chapter, work is essential to the development of ideas.

About Work, Talent, and Ideas

The decades have taught me patience with my muse; before she'll sit in my lap and sing, she visits me . . . like one of those vintage Hollywood monsters, almost human, whose inchoate grunts and rumbles move the heroine to declare, 'I think it's trying to tell me something.' Always, in the past, in her own good time, she has cleared her throat, reformed her voice—which is to say, mine. But she won't be hurried. —JOHN BARTH[5]

I've talked at length about providing yourself with lots of different kinds of resources to draw from. Sir Joshua Reynolds said, "It is vain for painters . . . to endeavour to

invent without materials on which the mind may work."[6]
The point of absorbing this visual nourishment is to give
your own ideas fertile ground in which to take hold.
When you have done the spadework and spent the time,
ideas, like seedlings, will slowly appear. But also like
seedlings, they cannot be looked at prematurely. Once
again, Van Gogh speaks so aptly:

> If you work diligently . . . without saying to
> yourself beforehand, 'I want to make this or that,'
> if you work as though you were making a pair of
> shoes, without artistic preoccupation, you will not
> always do well, but the days you least expect it, you
> will find a subject which holds its own with the
> work of those who have gone before us.[7]

Contrary to popular myth, artists don't go to the studio
only when they are in the right frame of mind. Francis
Bacon said he was never in the mood before he started.
"As you work, the mood grows on you. There are certain
images which suddenly get hold of me and I really want
to do them. But it's true to say that the excitement and
possibilities are in the working and obviously can only
come in the working."[8] To work in isolation, as most
artists must, requires discipline. The silence can be over-
whelming, and some people, who might otherwise be
artists, turn their creative talents elsewhere because they

cannot tolerate being alone for extended periods. Artists also—and this may surprise you—don't depend on talent, a capricious gift bestowed in unequal measure that will fail to stand up if not carefully cultivated through work. Of the two abilities, talent and the will to work, it is the latter that plays the more important role in an artist's development. The life of Van Gogh is a classic illustration of this point. His early drawings speak of intense effort with painfully little help from the talent that was to become so evident later.

In talking about how hard artists work, I am reminded of the story about the man who asked a Chinese artist to draw a rooster for him and was told to come back in a month. When he returned, the artist drew a fabulous rooster in a few minutes. The man objected to paying a large sum of money for something that took so little time, whereupon the artist opened the door to the next room in which there were hundreds of drawings of roosters.

Artists often set some kind of schedule for themselves and feel that the regular rhythm of daily involvement is essential. The important thing is to work as much as possible. Louise Nevelson always found ways to work with her assembled sculpture. She remarked that "even if I didn't want to compose, so I painted or stacked the

pieces."[9] The wonderful thing about working is that the more you do it, the easier it is to do, and the less likely it is you'll get stuck.

Ideas generate ideas. A certain momentum builds up, and you should make every effort to sustain it. An artist I talked to recently said she always stops when she knows what she is going to do so that it will be easy to start up again. When I am comfortably into a painting, I think about the next one and prepare a canvas to reduce the chances of being "unemployed" for any time. I encourage my students to have two pieces going at once because the pieces tend to cross-fertilize. Also, if students feel themselves getting bogged down on one work, they can quickly switch to working on the other. Many artists find that a forced separation from their studio caused by events like sickness, vacation, or a move makes it hard to begin again. As a student you may have experienced something like this when your most difficult moments in a studio class occurred at the beginning of the semester right after a break.

I've talked at length about sources and situations that are likely to be helpful in generating ideas. Perhaps you are now wondering, "But what really constitutes 'an idea'?" An idea is our visual reaction to something seen—in real life, in our memory, in our imagination, in our

dreams. Usually our seeing is colored by our memory and our unconscious selves. There are ideas that indicate how to develop a work in process and ideas that suggest how to finish it, but probably the most memorable ones are those that trigger the start of a piece. Ideas come in all sizes (and frequently at unlikely moments). The kind of complete revelation contained in the quotation from De Chirico at the beginning of this book is rare.

The experience of unexpectedly seeing something that sets you off—a color, a relationship, an event—isn't necessarily the sudden occurrence you think it is. It may have actually taken a long time for the idea to sift through your consciousness. Few people are aware that, for an artist, the gestation period for a particular idea may be many years. Georgia O'Keeffe first looked at bones in 1916, but they did not show up as a subject in her paintings until 1930. When he was twenty, Claude Monet spent two years of military service in Africa and was greatly impressed by the light and color he observed there. This impression contained, as he put it, "the germ" of his later work. Many artists experience the flash of a new idea, followed by a slowly dawning awareness that they've known about it vaguely for a long time. They just weren't ready to recognize it. Larry Rivers related the following typical story.

> One night in the early sixties I passed something on
> the Long Island Expressway just before the Queens
> tunnel that I must have seen for years. The billboard
> advertising cigars, Dutch Masters. I realized it was
> sort of perfect. It's weird, isn't it? You're looking at
> Rembrandt—in neon! It was too much, it was irre-
> sistible.[10]

Sometimes it's hard to know what is truly a visual
reaction. You may be powerfully affected by, say, family
relationships or political events, and then become totally
frustrated when you try to translate these experiences
into art. What has happened is that you've been touched
emotionally or intellectually, but not visually. I've spent
nearly all my summers in an old Vermont house inherited
from my parents. Essential as this place has been to my
life, I've never made a meaningful painting or print based
on this experience, and my drawings and photographs of
the house have been only modestly successful. Charles
Demuth said it very well: "They [the paintings] must be
understood through the eyes, and that's not the word
either. No writing, no talking, no singing, no dancing
will explain them. They are the final, the nth whoopee
of sight."[11] On the other hand, you may find yourself
drawn to some subject which, to all appearances, has no
great meaning. Yet some part of you resonates in sym-
pathy with what you're seeing, and it feels right when

you work with it. Mark Di Suvero commented on how artists relate to their sources. He said, "It is the reformation of material which is what all art is about . . . we reform it to where it does that tuning fork to our knowledge of form within."[12]

The kind of visual responses I have just described are sometimes characterized as being perceptual in nature. Perceptual art is based on something seen and attempts in various ways to reflect that experience. It's dependent on visual issues. I want to mention briefly another mode of thinking that leads to what is known as conceptual art. This art comes out of what an artist knows: ideas, theories, systems, mental manipulations, and written words. It is often activated by a proposition or a question. Marcel Duchamp, its earliest proponent, said it was art "at the service of the mind."[13] Although conceptual processes have played a significant role in the making of art during recent decades by such artists as Donald Judd, Sol LeWitt, and Carl Andre, their cerebral nature is probably of limited assistance when you are in need of basic resuscitation. You need to extend your work rather than contain it. Artists seem to arrive at this form of art rather than begin with it, and so I think, in the current context, this may not be a promising direction to explore.

There's a great temptation to speculate on what the

relationship is between the work of artists and their lives and personalities. Undoubtedly a connection exists. It's very obvious in the case of someone like Käthe Kollwitz, whose eloquent images of social injustice came directly out of her experience as the wife of a doctor for Berlin's poorest classes. More typically, however, the connection is tangential or invisible. The art may disclose some aspect of a person that is not manifest in any other way. We have been conditioned by the popular histories of artists like Van Gogh to connect personal tribulation with artistic intensity. Often the relationship between life and art is more likely to resemble that of Dame Agatha Christie and her mystery novels. James Ensor, for instance, led a quiet existence in a small Belgian town that gave no hint of the cities, with their surging barbaric masses, that appeared in his canvases. The relationship may be reversed. From Benvenuto Cellini's elegant, beautifully composed, precious sculpture one would never surmise that he himself was, among other things, a soldier, a philanderer, and the murderer of three men. In short, what will end up "inspiring" you are those things that satisfy some powerful internal visual need, which only time and much work will reveal.

When this happens, you may find you are having what seems initially to be a slightly odd experience. An object,

for example, ceases to be defined as we commonly understand it. A pepper is not a vegetable that is good in salads. It is a remarkably complex, undulating green surface vaguely suggestive of the human form. This is part of what is meant when people say that artists see "differently." It leads some artists to maintain that the subject of a work of art is not just the thing depicted. What they mean is that the overt subject is a vehicle for associations and visual issues such as movement, material quality, or color. Minor White said that "one should photograph objects, not only for what they are, but for what else they are."[14] An artist friend of mine explained that he paints parades because they give him the color experiences he seeks. Upon further consideration, we realized that the relationship is, in fact, more complex. There are a number of subjects that would give him similar color qualities, but none attracts him with the same combination of exuberance, joy, and naiveté that he finds in parades. Ultimately a marriage takes place between the visual need and a subject that will answer the need and at the same time satisfy the artist's other concerns and feelings.

There's another level on which *idea* and *subject* are not synonymous. These ideas are "merely" points of departure, the kernels from which greater units grow, the

observations that trigger larger developments. Alfred Hitchcock called them MacGuffins.[15] For writers of fiction they are elements that set the plot in motion: the receipt of a letter or an encounter on the street. With artists they manifest themselves in such notions as wanting to make more interesting black tones, or create a sense of alienation, or introduce new surface qualities. They may be suggested quite suddenly by something seen at random outside of one's usual frame of reference, or the recognition of a previously unseen connection. An artist I know found herself looking at the bright colors of a small portion of the Paris Métro floor and asked herself what would happen if she changed and used them for her large canvases of the American wilderness. It was an auspicious observation. Another event of this kind occurred when Ellsworth Kelly took a bus ride on Staten Island in 1954 and happened to notice how the shadows fell and moved across the pages of the paperback he was reading. He traced them and later transferred them to a sketchbook, where they became a long-standing theme in his paintings. These two examples also illustrate the fact that artists have their visual antennas up at all times because they never know when or from where they will receive an idea for their work.

·4·
Overcoming Difficulties

ORIGINALITY AND STYLE

Individuality is the beginning and end of all art.
—GOETHE

*'Tain't what you do / It's the way that you do it /
That's what gets results.*
—JAMES OLIVER YOUNG, MUSICIAN

Now we should consider the difficult question of how to be original. You've doubtless been told there is nothing that hasn't been done already—or, as Herman Melville, recalling Ecclesiastes, wrote in *Moby Dick*, "Verily there is nothing new under the sun." Fortunately, there's an unpretentious but strong idea that runs counter to this bleak pronouncement. It was put most succinctly by a jazz musician who said, "The way to be new is to be yourself."[1] Georgia O'Keeffe added, ". . . the simple fact of yourself—there it is—just you—no excitement about it—a very simple fact—the only thing you have—keep it as clear as you can."[2] From a very different world we hear a similar refrain. In a Toltec codex, we read: "The true

artist . . . maintains dialogue with his heart, meets things with his mind."[3]

You're probably asking, "What does that mean?" Think about what ideas, experiences, and passions have influenced you most profoundly. Do you find your eyes and your attention returning to certain things again and again? Perhaps there are some aspects of the world you are peculiarly sensitive to? The responses to these types of considerations may appear to be alternately of immense import and seemingly trivial. Somewhere among the answers lie the road markers for finding your own expression. You may very well not know for a long time which of these answers are the most significant; however, you can be certain they all point in the right direction.

The individuality of your artistic voice takes a while to mature, but be reassured, it's there. Only a very few artists, such as Dürer, Van Dyck, Bonington, Sargent, and Picasso, did notable work in their early teens. The overwhelming number of artists take much longer. (On the other end of the scale we find Auguste Rodin, who was thirty-six when he completed his first masterwork, and Milton Avery and Jean Dubuffet, who became full-time painters after the age of forty. Hokusai tells us that "since the age of six I have had the habit of sketching forms of objects. Although from about fifty I have often

published my pictorial works, before the seventieth year none is worthy.")[4] It's clear that the pace of artistic development is more likely to resemble that of the proverbial tortoise than the hare-like course of athletes and some musicians. (In the early Renaissance, students were bound to masters for twelve years.) Artists ordinarily take a great deal of time to arrive at the necessary high level of synthesis and coordination between eye, hand, and mind. This process can't be accelerated by anything except work.

It may happen that you find yourself making art early on that looks fully developed and receives some recognition. Perhaps it is mature, but if you're honest with yourself, you might have to admit that for you it lacks meaning or roots. You have discovered that your work is not genuinely yours, and you must reassess where you are going. You need to keep searching for a way of expressing yourself that will elicit the response from you: "That's *me*." Ben Shahn describes this experience in his early life as an artist.

> It was during those years that the inner critic first began to play hara-kiri with my insides. With such ironic words as, "It has a nice professional look about it," my inward demon was prone to ridicule or tear down my work in just those terms in which

I was wont to admire it. The questions, "Is that enough? Is that all?" began to plague me. Or, "This may be art, but is this my own art?" And then I began to realize that however professional my work might appear, even how original it might be, it still did not contain the central person which, for good or ill, was myself.[5]

You may also need to rethink your direction if you've been reworking the same images for a long time and, although it's all right from an objective viewpoint, you yourself are tired of it. Style is the visual expression of your individuality. Its formal aspects are determined by both conscious and unconscious choices you make. Think about how, based on years of practice, you've unconsciously developed a distinctive manner of walking, gesturing, and speaking. (Your cultural background may be an influence.) On a conscious level you've made decisions about the clothes you wear, the possessions you've acquired. Artistic style has to do with your ideas, the medium you select, and your relation to it.

Students often define style more narrowly to mean making one's own marks, and wonder if they'll ever have their own imprint or aesthetic autograph. I discovered a simple affirmative demonstration a few years ago when I looked closely at the scratch sheets (papers used to test a dip pen before working with it) made by my students in

a drawing class. They were unintentional by-products of the medium and had no conscious relationship with the drawing. What struck me was how different they all were. Each had a totally individual look in terms of the character of the marks made, the relationship of the marks to one another, and the space between them. (See fig. 9.) It takes time for your own style to emerge, but it will, just as, inevitably, the rest of you becomes a distinct individual.

Naturally, style will be more obvious and definable in some people's work than in others', the same way real-life "characters" stand out. It can also be intentionally repressed. Marcel Duchamp strove for the anonymity of engineering draftsmanship, and many artists in recent decades purposely eliminated all traces of their "hand." But their work is instantly recognizable from the other stylistic components, such as color, composition, and imagery. A normal part of learning is to attempt working in someone else's style, just as we emulate the behavior of various people in the process of growing up. (Degas strove to work like Poussin in his formative years.) Ultimately, however, your style must come about as the inevitable consequence of who you are. It will develop in the same certain way that you gravitated toward your favorite medium. To some extent you can promote this

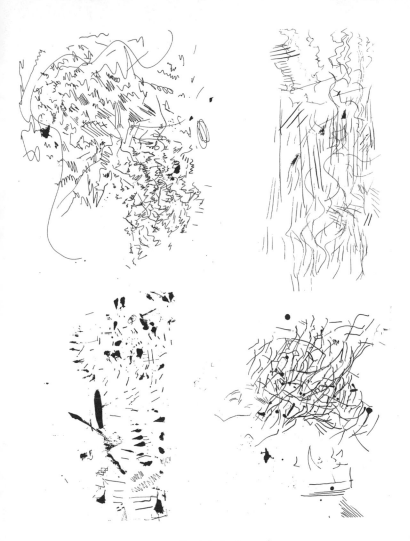

FIGURE 9. Scratch sheet samples.

development through conscious decisions about how you want your work to look, but always remember that imitating someone else won't make you that person. In fact, the premature, deliberate adoption of a style will only result in handicapping your development.

Another dilemma that confronts many students occurs when they have been working on both abstract and representational pieces. They are equally interested in the two directions and at the same time feel they are suffering from a visual split personality. Admittedly this is a problem, but not the hopeless one it might seem. Contrary to what you might suppose, these two modes of expression are not irreconcilable opposites. They simply allow for responses to different aspects of the same phenomena. (See page 83.) Artists working in a representational vein are concerned on some level that the subject of their visual experience be identifiable. Nonobjective artists dwell on components of visual experience in ways that do not necessarily add up to anything other than these components. The important point is that they have a common base of departure. Many artists have commented on this frequently close relationship. Charles Sheeler's work is representational, but he wrote, "I had come to feel that a picture could have incorporated in it the structural design implied in abstraction and be pre-

sented in a wholly realistic manner."[6] Wayne Thiebaud said in connection with his painting that realism seemed "alternately the most magical alchemy on the one hand and on the other the most abstract intellectually."[7] Overtly, Mark Rothko's abstract paintings couldn't look more different from Thiebaud's, yet Rothko wrote, "I am not interested in relationships of color or form or anything else . . . I am interested in only expressing the basic human emotions—tragedy, ecstasy, doom and so on. . . . And if you, as you say, are moved only by their color relationships, then you miss the point."[8] Richard Diebenkorn, who worked as both a representational and an abstract painter, made the connection this way: "Abstract means literally to draw from or separate. In this sense every artist is abstract . . . a realistic or non-objective approach makes no difference. The result is what counts."[9]

This may all sound good in theory, but perhaps you're still wondering how to solve the problem of being attracted to both figurative and abstract imagery. It's not easy and will take some time to work out. To begin with, put up several examples of each kind of work on the wall. Now ask yourself if there are any apparent similarities between them, such as line quality, composition, or color. If so, make a note of what these are. Then write

down what you like best about each type of work. Now try to create images that have the best of both worlds, as much as possible retaining those things which are most important to you. This will seem awkward and maybe even a bit artificial at first, but you should be able to come to some accommodation eventually. Don't be surprised if the balance of "ingredients" changes as you attempt to find the right combination. It may even happen that one direction wins out entirely over the other. But give them both an equal chance at the start.

CARDINAL SINS AND OTHER PROBLEMS

In terms of art, the only real answer that I know of is to do it. If you don't do it, you don't know what might happen. —HARRY CALLAHAN[10]

What you have to do now is work. (If you need help getting started, you may want to follow the suggestions offered in chapter 5.) Remember, "no deposit, no return." There's no right way to start. Like a beginning diver, you have no choice but to leap in. And you are jumping into a much bigger unknown than a swimming pool. It takes an act of courage because the odds don't appear to be in your favor. This situation is crippling for some art students who feel that anything they do must be good or it is not worth doing. To come to such a

conclusion is just as absurd as thinking a musician has to play beautifully from the start, or that an athlete will perform perfectly on the first try. We tolerate wrong notes and repetitions from a practicing musician, and we cheer on athletes as they try to improve their games. Why, then, be so unreasonably demanding of yourself? It turns an already troublesome problem into an impossibility. In his journal Delacroix wrote, "One should not be too difficult. An artist should not treat himself like an enemy." Later he added, "Artists who seek for perfection in everything achieve it in nothing."[11] We tend to imagine that artists of the Renaissance made masterpieces with the regularity and dependability of the rising sun. So it should be comforting to know that in 1436 Leon Battista Alberti wrote (and he was paraphrasing Cicero) that "there is no art which has not had its beginnings in things full of errors. Nothing is at the same time both new and perfect."[12]

Don't worry about what will happen. You will most certainly make some terrible things. That's O.K., even necessary. All artists have made bad work, but most of it gets destroyed, so we don't know about it. By the way, this need for the freedom to make poor art is another reason for having your own private workplace—though it's tough doing bad art even when you're all alone. If

what you are making is open to scrutiny all the time, you won't permit yourself to work through difficult periods. Not allowing yourself to learn by making mistakes leads to paralysis as surely as it would for a singer who couldn't get past a wrong note. Finally, there may even be something positive to be gained from poor work. If you question why you did it, or why it took a wrong turn, it may point out some important information. (Remember, too, that once you are out of school, no one will care how good your grades were.)

Some other ideas ought to be released from the closet of bad work because they don't belong there. First among these are technical taboos that creep into teaching. A few I've heard are: "Stay away from watercolor—it's too hard"; "Avoid black"; and "Yellow is a very difficult color—use it sparingly." Nobody who ever wanted to play a particular musical instrument badly enough stayed away from it because it was difficult. Paint companies don't make a variety of blacks because hardly anyone uses them. And how, then, could Bonnard say there could never be too much yellow? "Don't mix more than three colors or you'll get mud" is another such prohibition that comes to mind. First of all, they don't necessarily make mud, and what's more, if mud colors automatically disqualified certain art, we would have to dismiss

artists such as Louise Bourgeois, Jean Dubuffet, and Oskar Kokoschka, not to mention anyone who works in clay. Josef Albers, whose paintings are almost exclusively explorations of color, said that "every color goes with every other color if the quantities are right."[13] You'll also find quite a number of great landscape painters who don't follow the rule "You need a foreground, middle ground, and background." These observations should suggest to you that there are no sure problems, just as there are no sure solutions. I was reminded of this recently when my students made four-by-eight-foot woodcuts and mono-types to be printed by a steamroller. I forgot to tell them that working on such a large scale could create unforeseen difficulties. They went ahead without knowing there might be problems, and there weren't any.

The bad-work label is, of course, applied most often to content. Uneducated audiences tend to turn away from subjects that disturb. If you are truly committed to such ideas, you have the choice of taking a confrontational stance or working in a medium such as printmaking, photography, or drawing, that the viewer can put aside. Much as we enjoy a mystery novel, most of us would not choose to be involved in a world of crime and suspense all the time. Some art is meant to be looked at only sometimes. For the last half-century, critics have fre-

quently dismissed artists whose work was socially conscious. If they were right in their assessment, we would have to erase the names of people like Goya, Daumier, Grosz, Beckmann, and Siqueiros from the index of art history. Modernism has its heretics as well as its heroes: to wit, those artists whose work contains emotion, sentiment, romanticism, and nostalgia. Censuring these qualities would require the elimination of more names, among them, Eakins, Rodin, Ryder, Hopper, Orozco, and Chagall.

I noted earlier that the history of art is useful because the critical powers it provides are a defense against trendy pressures. In a time when the making and marketing of art have become almost synonymous, many students feel they should limit their thinking to what the art scene and major art periodicals have defined as politically correct. This creates an enormously restrictive atmosphere and fosters entirely external, artificial criteria for making decisions about what to do. The consequences have caused great distress for students who felt increasingly wrong the more they tried to be "right." Jane Freilicher spoke pointedly to this issue when she said, "To strain after innovation, to worry about being 'on the cutting edge' (a phrase I hate), reflects concern for a place in

history or for one's career rather than for the authenticity of one's painting."[14]

While the prohibitions I've mentioned are imposed by others, we also tend to burden ourselves with many of our own, created by our private inner censors with their unending cautionary commands. One of these results in our tendency to treat accidents in the creation of art the same way we would view a similar encounter with a car. It's true that a strike which turns your marble sculpture into a heap of crushed stone is a tragedy. (Except if you're Michelangelo, who took a piece of marble "ruined" by another artist and came up with the *David*.) But in a more flexible medium, an accident may be your MacGuffin. The unintended visual events that happen are not automatically negative, and you should be on the alert for the possibilities they suggest. They're part of the constant exchange that takes place between you and the piece you're making. Francis Bacon said:

> You know in my case all painting—and the older I get, the more it becomes so—is an accident. I foresee it and yet I hardly ever carry it out as I foresee it. It transforms itself by the actual paint. I don't in fact know very often what the paint will do, and it does many things which are very much

better than I could make it do. Perhaps one could say it's not an accident, because it becomes a selective process what part of the accident one chooses to preserve.[15]

YOU'RE STILL STUCK?

In spite of taking all of the preceding ideas into account as a form of preventive maintenance, you might nevertheless come to an impasse. While the experience can happen to anyone, it sometimes affects men and women differently. Men tend to recognize the event as a problem, but women sometimes take it as a sign that perhaps they should not be artists.[16] This is an unfair and mistaken conclusion. Moreover, while the experience of being at a loss for ideas is not gender-related, the mythological muse was regarded by the ancients as feminine.

First of all, keep in mind that *thinking* about what you're going to do is a way of stalling. If you really could imagine what would happen when you made an image, there would be no need to do it. Even trying to imagine what a finished work of art will look like will probably lead to expectations that will be let down by the real experience. Making art is not solely an act of will. Rather it's the outcome of a dialogue between artists and their art. You may know what you think at the start, but there is no way to predict what your emerging creation will

say back to you in the process. It might even return information that is uncomfortable, difficult, or something you just plain don't like. Picasso spoke for most artists when he said, "A picture is not thought out and settled beforehand. While it is being done it changes as one's thoughts change."[17] The writer Annie Dillard also paints and has spoken eloquently about the process of creation:

> First you shape the vision of what the projected work of art will be. The vision, I stress, is no marvelous thing: . . . Many aspects of the work are still uncertain, of course; you know that. You know that if you proceed you will change things and learn things. . . . But you are wrong if you think that in the actual writing, or in the actual painting, you are filling in the vision. You cannot fill in the vision. You cannot even bring the vision to light. You are wrong if you think that you can in any way take the vision and tame it to the page. . . . The vision is not so much destroyed, exactly, as it is, by the time you have finished, forgotten. It has been replaced by this changeling. . . .[18]

The difference between intention and realization is not quite as evident among artists who work in less malleable media. Barbara Hepworth remarked that, as a sculptor who carved, she needed to have a clear sense of the forms

before she started. Photographers also have fewer opportunities for visual changes, because their images are already partially realized.

If you are at loss for how to proceed on a single piece, look at it in a mirror. For a few seconds you'll have a fresh vision and the problem may be evident. Alberti put it more colorfully: "It is marvelous how every weakness . . . is so manifestly deformed in the mirror."[19] You might want to get a second opinion from artist friends. Or you could try contemplating your work when it or you are upside down. (Romare Bearden regularly looked at reproductions of Vermeer paintings placed upside down to see "real great abstraction.")[20] Put it at the foot of your bed or on the refrigerator—a place where you'll look at it even when you're not consciously thinking about it. Sometimes you can see things better when they are smaller, such as in an instant-camera shot or with a reducing glass. Yet another approach is to write down a description of what you are trying to achieve. Occasionally you may find a discrepancy between what you have done and what you say you are attempting to accomplish, and this will provide a breakthrough.

If these remedies don't help, and your work will fit, put it in a copy machine. Instantly you'll have a half-

dozen versions on which to experiment. This procedure tends to have a very liberating effect because your wildest revisions will never damage the original. (Your willingness to make changes is largely dependent on how risky the proposition appears.) If these immediate remedies are not effective, put the work aside. Concede that, for the moment, the problem has gotten the best of you. Renoir is reputed to have said that after one had put a canvas out of sight for three months and had forgotten the trials, one could see it in a fresh light. While you may not need three months, consider putting your problem away for at least two or three weeks, and work on something else in the meantime.

But if the worst has happened and you've ground to a complete halt, here are more ideas that should help. Try doing a one-person show for yourself. Take ten to twenty recent drawings (or whatever it is you are doing) and put them up where you can see them all together. What are the most successful pieces or passages? Do they relate to each other in any way? Do they have something in common, or are there any recurrent themes? What do you like in what you see? What do you hate? (Knowing what you dislike in your efforts is just as important as identifying the positive qualities.) It's surprising how

often you can find out something about your work from
a group of pieces that is not evident when you look at
them one at a time.

Check over your notebooks, clippings, and photo-
graphs. Look at books and magazines—the latter need
not necessarily be art-related. Think about doing images
associated with, not illustrating, a favorite novel or poem.
Dreams and music may provoke visual responses. Con-
sider a revision of something you have done. Could you
do it in a better way? An idea is not necessarily exhausted
in one effort. This is what leads artists to do series.
Imagine if Monet had stopped after doing one painting
of Rouen Cathedral. In 1927 Stuart Davis took an electric
fan, a rubber glove, and an eggbeater and nailed them to
a table. He used these things as his exclusive subject
matter for a year and remarked later that everything he
did subsequently was based on that experience. (Print-
makers and photographers are more accustomed than
other artists to thinking in terms of sequential images.)
Make photocopies of a few of your drawings, cut them
up, and recombine them in new relationships. Go to a
museum or two (art, science, history, and/or natural
history). Cézanne remarked, "The Louvre is the book in
which we learn to read."[21] You may need to investigate
some more unusual source. When I was in graduate

school, there were no courses on anatomy, but I was intrigued by the fact that many artists had considered its study essential to their training. So I and a fellow student went to the medical school and arranged to draw in the gross anatomy class. While this study was not part of the curriculum, it was invaluable to my development.

If these activities, based on what you've already done, don't work out, you should consider a different direction. You might go back over your sketchbook and see if there's something you've never tried. When Philip Guston was asked how he decided what he was going to do next, he replied that sometimes he would try something he'd never seen before.[22] Or you could go just partway in this direction and ask yourself, "What if?" What if you used only cool colors, or made everything as ugly as possible? What if your dog image split in half and its owner appeared in the middle, your perfect white geometric forms were invaded by some neon organic ones, your small, delicate plaster piece became ten times as big and was cast in rubbery plastic instead? "What if?" has been a persistent theme in twentieth-century art and a major influence on its revolutionary character.

One of Leonardo da Vinci's suggestions for stimulating the imagination was to "look at crumbling walls, glowing embers, clouds or mold, because in these irreg-

ular shapes one can find strange inventions just as we are apt to project words into the sound of church bells."[23] In 1785 the English artist Alexander Cozens developed an idea of Leonardo's about ink blotches and wrote "An Essay on the Invention of Landscape Composition." His thesis was that using ink blotches and loosely applied haphazard brush drawing could lead to more imaginative landscape images. Today many artists feel it is easier to begin on a surface that already has some vague forms on it, something to start a dialogue with. Suspend your will briefly and put down some random marks (as suggested by Van Gogh, among others) on which your imagination can then work. Or you could collage something onto your surface and then proceed with that as a starting point.

Experiment with new tools or a different medium. Artists are sometimes frustrated because the tools they are using don't seem capable of achieving the effects they are looking for. My first attempts at painting were dismal because no one told me about sable brushes. Sometimes a more random change is called for. Try working with the same materials your favorite artist employed, provided they are not what you are currently using. If they are ones you've never worked with before, your initial ineptitude won't permit you to take your efforts too

seriously. The resulting sense of play reduces your anxiety, and may even point to a new direction. Take into account the format of your work. It is actually the first decision you make, although most people never consider the fact. A piece of paper with one dimension three times that of the other is sure to have very different suggestive properties from one with a circular format. Consider the size you're working with and bear in mind that embryonic ideas are not ready for large formats. Composers' first notations of a theme are not scores for a symphony orchestra. Working small also results in a quick turnover of ideas, and you'll avoid getting bogged down by long efforts on unrewarding pieces. Robert Motherwell said, "It's possible to paint a monumental picture that's only 10″ wide *if* one has a sense of scale, which is very different from a sense of size."[24] Alberto Giacometti made quite small pieces between 1942 and 1945. All of his work from those years would have filled little more than a shoe box. And Giorgio Morandi's entire life's work was on a very small scale. If you are having difficulties, grand expectations of any kind are likely to be inhibiting.

Unfortunately, nothing comes of nothing; so at all costs, try to keep working. Just looking at a blank sheet of paper is an absolute guarantee of failure. If none of the preceding suggestions have pried your creative powers

loose, you may need to adopt a disciplinary approach. Set yourself a daily task. The following account by Jacques Lipchitz will give you an example.

> Next came the fire in 1952 when everything in my studio burned, and the bronze foundry offered me a space where I could work. At that time I experienced several other misfortunes; I had fallen, as it were, from my horse and I began to think that maybe all was finished with me. Then, in order to see what was really happening, I decided to take my creative temperature. I determined to go to the foundry each morning and every day to make a spontaneous sculpture from one of the leftover wax chisels [small wax casts]. In twenty-six working days I made twenty-six sculptures. It was a cure. After that I was ready to go on—to go on to more planned work.[25]

The task you decide on should be of limited duration each day (no more than an hour or two) but moderately demanding—like physical exercise. It should make you feel that you have done something, yet not wear you out so that you fail to continue on successive days. The following three procedures will help you envision the kinds of problems you might set up for yourself to investigate.[26]

- Select an object, such as a scissors or a shoe, and take it on a "trip through the world." Place it in

many different environments, appropriate and in-
appropriate to the nature of the object.

- Take a place that is meaningful to you and rope off
 the "site" in your mind or in fact. You must be able
 to observe the area from any side, and its contents
 should not exceed what you can draw comfortably
 within the allotted time.

- Walk around and record how surfaces intersect with
 each other. What happens where the telephone,
 your coffee cup, and your chair "meet" visually?
 Your drawing should extend just to the moment
 where it ceases to be abstract.

There are probably as many ways to get started as there
are ways of chasing the blues. Use anything that works
even if it seems ridiculous or not what an artist does. In
this case, the end justifies the means.

·5·
Getting Started Figuratively

Only you can see with your eyes.
—ANONYMOUS

Let's assume you have been given an open drawing assignment. It's due shortly, and you don't have enough time or the means to go somewhere special to come up with an unusual solution. You need a subject you have easy access to at any time of day—preferably one that's going to stay put for a while. You're not allowed to copy. Obviously, some form of still life might provide the answer, but you immediately reject all the ideas that come up under this heading: bottles, "drapery," fruit, and so on. Good. These are the elements of a still life that's already a cliché in your head—and one that will almost certainly be stillborn on paper. It is, in fact, hard to recall works by any major artists based on such tired formulas.

Let's try thinking about still life in some other way. By definition, it simply means a group of things of small to medium size. While you may never have contemplated

74

the notion in quite this way, your life is full of clusters of objects: the items on top of your bureau, your medicine cabinet, the tools on your workbench, to name just a few. In fact, you leave still lifes behind you all day long: your unmade bed, last night's or last week's clothes on the floor, even the remains of a meal before the table has been cleared. (See fig. 10.) Recently Elizabeth Murray said she finds her art "at home, right in front of you. I paint about the things that surround me—things that I pick up and handle every day. That's what art is. Art is an epiphany in a coffee cup."[1] (Robert Rauschenberg put it a little differently when he said that there is no such thing as a poor subject.)

There are several good things to be said about this type of subject matter. It doesn't have to be arranged, because it has been ordered already by routine human activity. In fact, you should resist the impulse to rearrange anything, because you'll probably only succeed in making forced, obviously posed, or even more ordinary relationships. (After Matisse was disappointed with a bouquet he had arranged for a painting, Renoir told him to go around to the side he had not looked at.) Furthermore, these objects have a special relationship to you. Intentionally or subconsciously, we all surround ourselves with things we have chosen. These are "autobiographical" items we care

about on some level. (Granted, there is a big difference between the perceived value of your toothbrush and a favorite photograph.) Witness our distress if they are misplaced or even lost in a robbery or fire. We don't feel the same way about other people's "stuff." Our possessions are representative of our lives.

It is generally more satisfying to draw things you relate to in a special way. Usually artists feel attracted in some positive manner to whatever forms the content of their work, but some things may attract us because they generate a strong negative response, such as the way many of us view spiders, parking tickets, alarm clocks, or anchovies. I had a student many years ago who did a woodcut portrait of her father, whom she hated. Her deep emotional involvement found expression in the cutting of his likeness, and the result was a striking image that I still recall.

You may have had an inkling of the importance of feeling connected to your subject in previous drawing experiences where, for no apparent reason, some problems seemed more interesting (and came easier) than others. In addition, you can be sure your drawing of your surroundings will have a modest degree of originality. After all, nobody else ever made a sketch of the dishes in your sink. That you probably can't think of a

FIGURE 10. Fairfield Porter, *Still-Life*, 1975. Watercolor. Courtesy of Barbara Ingber.

similar image is also helpful. You won't have a predetermined idea of the outcome. And if you don't know how your drawing will (or should) appear, you will be forced to observe with more concentration. Finally, your drawing will have a contemporary quality because it is most certainly of your time. One of the many problems with traditional still-life concepts is that they are felt to be based on some vague historical aesthetic and, as in all noncreative revivals, are irrelevant to contemporary art.

Let's go back to the assignment. Suppose you've completed a drawing of the still life on top of your bureau. While the assignment is satisfied, you're not especially happy with the results. Let's say that you did, however, rather enjoy drawing your hairbrush. This is the most important thing you've learned from the whole exercise. First of all, it suggests something about the subsequent drawings. Perhaps the brush should be the main, or even the only, subject next time. Maybe, for the following drawing, you should go around and collect all the brushes you can find; paintbrushes, toothbrushes, dish brushes, shoe brushes, hand brooms, and so forth. (See figs. 11 and 12.) By the fourth drawing, you may be concentrating on the bristles, which you've found are the most interesting or fun to draw. Finally, you might find yourself exploring just the linear qualities suggested by the

FIGURE 11. Jim Dine, *Five Paintbrushes*, 1972. Etching. Yale University Art Gallery. Director's Discretionary Purchase Fund.

FIGURE 12. Jasper Johns, *Painted Bronze*, 1960.
© Jasper Johns–VAGA, New York, 1993.

bristles, and the composition has become an abstract one. I've just demonstrated in a "fast forward" summary how an idea may develop.

This projected sequence is also a lesson in decision making and basic editing. Making art is, among other things, about making choices. There are a surprising number to be made even if you are contemplating something as simple as an apple. Audrey Flack tells us than an apple may be "red or green or yellow or various mixtures. . . . It can be rotting or fresh . . . sliced or whole . . . pure or scarred . . . full or shrivelled. It can be the apple Eve presented to Adam; . . . Snow White's apple; Red Riding Hood's apple; the Big Apple."[2] You can see how the form and meaning change with each of these decisions. Robert Motherwell commented even more specifically on this critical activity:

> . . . Suddenly I realized that each brush stroke is a decision, and it's a decision not only aesthetically:— will this look more beautiful?—it's a decision that has to do with one's gut: it's getting too heavy, too light. It has to do with one's sense of sensuality: the surface is getting too coarse, or not fine enough. It has to do with one's sense of life: is it airy enough or is it leaden? It has to do with one's own inner sense of weights: I happen to be a heavy, awkward, clumsy man, and if something gets too airy—prob-

ably though I admire it very much—it doesn't feel like my *self* to me. But in the end I realize that whatever meaning that picture has is the accumulated meaning of ten thousand brush strokes, each one being decided as it was painted.[3]

The entire character of an artist's work is the consequence of one or more major (although not necessarily entirely conscious) decisions about its content. Clearly no artist (not even Picasso) ever covered the entire range of available major subjects. Michelangelo did not paint landscapes, Turner is not known for his portraits, and Toulouse-Lautrec did not create biblical tableaux. These differences were already remarked upon in the early Renaissance. After describing what several ancient painters were good at, Leon Battista Alberti said in his fifteenth-century treatise on painting, ". . . thus there were unequal faculties in each, for nature gives to each intellect its own gifts."[4] Perhaps we should look at Rembrandt a little more closely. His paintings consist of portraits, biblical and mythological themes, and landscapes. He is known above all for the psychological depth in his rendering of people. Since he was one of the greatest artists of all time, we might ask why he didn't, for example, paint still lifes. Certainly this choice was available to him, and if we look at the work of his contemporaries, we see

that there was a market for such work. Maybe the pictorial possibilities in still lifes didn't interest him very much.

Making choices is also implicitly about making judgments. Your decisions about what to include and what to leave out, what to emphasize and what to play down, are based on what you think is important. Take a number of artists and ask them to work from the same scene; you will get as many different drawings. One may be of a rocky landscape with cows, the second of a scene with pastureland, utility poles, and a cement mixer going by, and the third will show blowing northeastern wildflowers against a sky with great cumulus clouds. The first interpretation emphasizes the land and animals, the second comments on the impact of people on nature, and the third shows a naturalist's delight in the movement of plants and sky. Each artist has a different idea about what matters.

As an initial proposition, we have used the idea of a still life—Rembrandt notwithstanding. The same kind of thinking can be applied to larger subjects. The still life could be extended to an interior view. Here again you encounter the problem of reference material. Our living spaces generally don't have the charm we associate with pictures of interiors in museums. You have to replace the

popular notion of charm with your own private response. What aspects of the room have meaning for you? Do you have special feelings about a certain chair you prefer or associate with someone you care for, or dislike? (See fig. 13.) Is it something about the relationships between pieces of furniture, crowded or widely spaced, baroque alongside plain, the character of the curtains or the rug? Perhaps the important qualities are more abstract: the color of the light at a certain time of day or the geometry of the windows and doors. You might consider rooms that are "not for show," such as the bathroom, the cellar, or the attic. Bathrooms offer lots of shiny formal elements, cellars may suggest complex mechanical problems as well as random junk still lifes, and attics tend to harbor sentimental associations.

The usual ideas about what constitutes a landscape have many of the same traditional restrictions as still lifes. (By the way, don't overlook the possibility of an image that contains both a still life and a landscape.) None of us, on going outdoors, would find a Constable view. So once again, instead of looking for a scene that exists in your head, based on examples you may have seen in books or museums, contemplate the area where you live now. Base your work on your own geographic and cultural environment. (After all, that's what Constable did.) The

FIGURE 13. Vincent Van Gogh, *Gauguin's Chair*, 1888. Oil on canvas.
Vincent Van Gogh Foundation / Van Gogh Museum, Amsterdam.

art you have taken in previously will be informing your observation almost automatically. What are the characteristics of your surroundings, and which of these are significant to you? Are there certain views across some lawns, over some factories, or down a street that you habitually look at? Do they elicit pleasure, revulsion, or depression? Or are you intrigued by more abstract responses, such as color relationships, repetitive patterns, or sequences of overlapping forms? What time of day is it? Or doesn't that matter? (See fig. 14.) What is your viewpoint? Are you observing your subject from below some high cliffs, or are you standing on an elevated subway platform? Do you see ten miles of verdant farmland, a gas station, or a piece of newspaper caught between trash cans by the curb? How much of the view should you include? Here you have to employ another example of editing. To draw everything indiscriminately may be too complicated or too boring, or both. If you're in doubt about where to set the limits of your composition, use an empty 35mm slide frame. By moving it around and holding it at varying distances from your eye, you can isolate the section of what you're looking at that interests you the most. Incidentally, a slide frame used this way is a useful tool for any subject.

So far, we've considered two traditional forms of im-

FIGURE 14. Yvonne Jacquette, *Northwest View from the Empire State Building*, 1982. Lithograph. Courtesy Brooke Alexander Editions, New York.

agery, still life and landscape. Many ideas can be generated by things and places that do not fall obviously into these categories. If you have a job, think about where you work. (See fig. 15.) Are there spaces, machines or other aspects of your work environment that make an impression on you? Inspiration may come from things as big as a sports stadium or as small as a tangle of cash register tape. A student of mine, at a loss for what to do, mentioned that he worked as a night watchman in a steel rolling mill. I suggested that he look for a subject there, and he came back with a powerful composition of a vast, gloomy industrial interior. Restaurant work, which is all too familiar to many students, has provided several of mine with ideas: a still life of the sugar bowl, napkin holder, ketchup, salt and pepper setup on the counter, an abstraction based on the floor tiles, and a scathing caricature of the customers.

Activities we participate in for pleasure may also be inspirations for art, although I must warn you this is a subject fraught with visual clichés. A good way to avoid them is to bring your own knowledge of the activity to the drawing. This might permit you to depict the first audition rather than the great singer, the electronic paraphernalia of a rock group rather than yet another spotlit silhouette of the lead musician, or the dancing of the

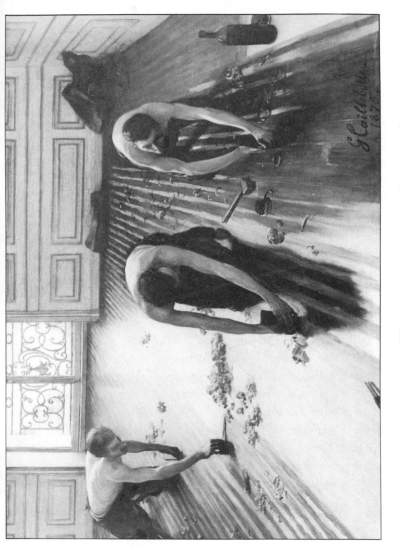

FIGURE 15. Gustave Caillebotte, *Les Raboteurs de Parquet* (Floor-scrapers), 1875.
Oil on canvas. Musée d'Orsay, Paris.

organist's feet instead of the whole gospel choir. One of my students was an accomplished gymnast. He knew that the moment of handchalking could be as compelling as the perfect Gienger. Another student, in response to my question about what he would do if he had a completely free day, told me he would work on his car. I asked him to draw the motor. The result of the first try was promising; a whole series of motor drawings followed. Then, slowly, the car parts began to take on qualities suggestive of insects. What had started as a rather pedestrian idea evolved into a wonderful fantasy. In a related manner, but with an entirely different effect, Fernand Léger's images marry machine and human forms.

Finally, a word about people. No other subject is so mined with worn and trite ideas—and, at the same time, none holds quite the same fascination. The best way to avoid some of the obvious problems is to think about specific individuals rather than people in general. Don't decide to do a generic "old figure." Find a real elderly person: your grandparent or a neighbor. You'll probably discover the stereotype is inaccurate: they don't use canes or wear funny old clothes. You may also discover the reality is either less interesting than you thought or totally involving. Perhaps groups of people attract your

attention: workers around a manhole, people at a laundromat, players in a video arcade. Another student came up with a series about people waiting on line to buy tickets at the railroad station. Something about how they stood and the way they related to each other spatially, but not emotionally, captured her imagination.

Again, it's important to consider how much of the person you need to draw and from what angle. Are you interested in just the head, a full-length portrait, or a view from the back? (My husband was once faced with the daunting problem of filming an interview with two drug addicts who refused to face the camera. Even though they were shot from behind, the subjects' body movements and hand gestures were so telling that the invisibility of their faces was inconsequential.) Should your subject be standing or sitting, making eye contact with you, or involved in some activity? One good place for figure drawings is the beach. There are unlimited "models" in every shape, many of whom stay in the same position for long periods.

In all the previous comments, we've been involved with the factual recording of things seen. Editing has been restricted to the determination of what to look at and how much of it to include. This may be a very rewarding experience for some people, but for others it

may not be sufficiently flexible. One of the simplest departures involves leaving out certain information. Many landscape artists who are mainly interested in natural forms routinely eliminate all manmade artifacts. Be honest about your reasons for leaving something out. Is it because you feel the factory, car, or people would interfere with the mood of your drawing, or are you leaving them out because they don't seem sufficiently "artistic"?

Maybe you are avoiding doing people because you don't know how to draw them. If this is the explanation, learn how to draw human subjects. Figure drawing has been taught for centuries, and there is no reason why you can't obtain a working knowledge of the human form. If your first life drawing experience was not adequate, try another instructor. We teachers all have different approaches. What you create should be determined by your needs, not your weaknesses. This is a situation that students seem to be unwilling to admit to themselves, and it prevents them from fully realizing where their abilities lie. You've probably noticed that skaters and dancers who perform with the most freedom are those with the greatest skills at their command. Not having the necessary skills as an artist can hobble you just as effec-

tively as not having any ideas. Skills come in great variety, and diverse objectives require them in different types and amounts.

Other ways of discovering what you want to do involve different processes. Sometimes memories provide ideas. The way we think of things, however, is very different from how we see them. We've all been painfully reminded of this in our frustration when trying to put down a remembered experience. We find we don't recall with the apparent accuracy of a camera. At the same time, we should take into account how often a photograph fails to capture the feel of a moment or place. Sometimes, in its objective truth, a photograph contradicts our memory; the Ferris wheel was in fact not very big, the ugly neighborhood actually had a lot of character, or the "vicious dog" was really old and fat. A collage of associations may be more evocative than a direct description. A favorite place might be recalled by a particular chair, ants on the peonies, or the wallpaper pattern in the kitchen. (See fig. 16.) The same kind of selected associations might be used to describe a person: rimless eyeglasses, a hard hat, work boots, blueprints, and a can of beer. A further extension of this kind of thinking was expressed by Fairfield Porter, who owned a house in Maine built by

FIGURE 16. Arthur G. Dove, *Grandmother*, 1925. Collage of shingles, needlepoint, page from the Concordance, pressed flowers, and ferns. 20″ x 21 ¼″. Collection, the Museum of Modern Art, New York. Gift of Philip L. Goodwin (by exchange).

his father, when he said, "And so in a sense if I paint that house in Maine, I'm also painting a portrait of my father."[5]

Working with the principle of collage has several useful applications. In the context of this book, its primary value is that you automatically begin with something. In a sense, part of your image has already been made. Collage gives you the freedom to compose with several subjects that could not exist together in the real world, and permits you to derive new meanings from these displaced and dissonant images. The freedom to move things around and compose at random recommends itself to artists who are bogged down. Usually in talking about subject matter, we describe it in terms of a statement; the picture is of a view of Mont Sainte-Victoire, shows jockeys at a racetrack, or presents a portrait of Marilyn Monroe. Collage often turns the subject into something ambiguous or a question because the relationships between its various components can't be explained by our own experience. While one might be able to associate the name Webster with a brand of American cigars as well as with Daniel Webster, the rest of Larry Rivers's collage *Webster and Europe* (fig. 17) leaves the viewer with a question. Why is Webster posed against an eighteenth-century print of Rome by Giovanni Battista Piranesi

FIGURE 17. Larry Rivers, *Webster and Europe*, 1967. Relief collage.
© Larry Rivers/VAGA, New York 1993. Photo by Stan Johnson
© Phoenix Art Museum.

when neither the statesman nor the cigars have any connection with Italy? And, even if you were quite familiar with the cigar box cover, the wavy, flower-filled frame would not provide any explanation beyond its derivation. Rivers himself refers to works like this rather enigmatically; he says simply that they are some kind of comment on a subject.

Thinking about collages provides a handy introduction to a whole other category of imagery—fantasy. The ideas discussed so far have dealt with "real" life. In imaginary visions we find elements of the existing world completely transformed so that the physical characteristics and consequently the meaning are altered. It's an area of art that is often especially appealing for young artists. At the same time it's likely to be one of the most difficult. When you're dealing with the actual world, you have two firm bases of reference: what you can observe and what other artists have put down. When you are working with fantastic images, you draw self-consciously on your imagination and usually subconsciously on the work of other artists. The first tends to be weaker than you hoped and the second stronger than you supposed. Commercial images of other worlds sometimes exert an undue influence. Bear in mind that they tend to appear fairly similar and are quite predictable. If, on the other hand, you look

at imaginary images by artists such as Bosch, Blake, Redon, Doré, Klee, Ernst, or Magritte, you will realize they have nothing at all in common. Fantastic imagery is a sphere where invention is at an all-time premium. If you're having difficulty coming up with ideas, I would not recommend trying to overcome the problem via imaginary worlds.

Matisse observed that "the object must act powerfully on the imagination; the artist's feeling expressing itself through the object must make the object worthy of interest; it says only what it is made to say."[6] The quality of your work is directly related to your involvement with what you are doing. In music, it's the difference between playing all the notes mechanically and a creative, expressive rendition of the piece. Train your awareness of when you are engaged in drawing and when you are merely pushing the pencil. The former will happen more often if you select subjects you respond to. These may include things you hate as well as those you care for. Remember satire, wit, and humor if you're so inclined. Serious art doesn't have to be serious. (See fig. 18.)

Rainer Maria Rilke's advice in *Letters to a Young Poet* applies equally to the beginning artist:

> . . . avoid those forms that are too facile and ordinary: they are the hardest to work with, and it

FIGURE 18. Claes Oldenburg, *Screwarch Bridge Model in Progress*, 1980–81. Bronze, aluminum, and plastic, painted. Photo courtesy of Lippincott, Inc.

takes a great, fully ripened power to create something individual where good, even glorious traditions exist in abundance. So rescue yourself from these general themes and write about what your everyday life offers you; describe your sorrows and desires, the thoughts that pass through your mind and your belief in some kind of beauty—describe all these with heartfelt, silent, humble sincerity and, when you express yourself, use the Things around you, the images from your dreams, and the objects you remember.[7]

So don't be concerned if what attracts and moves you turns out to be objectively trivial and not the "stuff of art." (See fig. 19.) One of my students, to his amazement, discovered that the bugs he found in his refrigerator one night became the starting idea for several prints. Jim Dine says he's always aware of what's on his studio floor because the accidental things there often supply him with useful material. Art is made by artists, not by arbitrary definition.

Nor should you be put off by parental observations or a roommate's quizzical expressions. (Artists are disadvantaged in this respect. Other people can't see what a writer is working on unless they are handed the manuscript. The nature of an artist's activity is more public and, unfortunately, open to unsolicited comment.) The im-

FIGURE 19. Janet Fish, *3 Pickle Jars*, 1972. Oil on canvas. Courtesy Robert Miller Gallery, New York.

pulse for making art at any level must be dictated by your inner conviction only: what commands you, not what "they" like. Trust yourself. Teachers may offer suggestions later, which you must then weigh against your own views. You may not know why you respond much more powerfully to drawing some things compared with others. It's not essential to know why. It is, however, of paramount importance to know what moves you and to act on that knowledge. Anne Truitt wrote that "the most demanding part of living a lifetime as an artist is the strict discipline of forcing oneself to work steadfastly along the nerve of one's own most intimate sensitivity."[8]

·6·
A Few Final Thoughts

The evidence is overwhelming that creative ideas do not come in isolation. Gold miners have to pan through lots of worthless gravel to find a precious nugget. The experience of a breakthrough is not limited to artists. It happens to mathematicians and scientists as well. I find the following passage by the great mathematician Henri Poincaré particularly appropriate.

> These sudden inspirations . . . never happen except after some days of voluntary effort which has appeared absolutely fruitless and whence nothing good seems to have come, where the way taken seems totally astray. These efforts then have not been as sterile as one thinks; they have set agoing the unconscious machine and without them it would not have moved and would have produced nothing.[1]

It's bad to feel that you are without ideas, even worse to imagine you are the only one with this affliction. On the assumption that misery loves company, I've included the experiences of a great number of artists (and a few people from other fields) in this book because I think

their comments will make you feel less alone. Clearly there is no single prescription for overcoming your creative difficulties. I hope, however, that in reading these pages, some ideas will have occurred to you about how to get started. Don't let them get away from you because they don't seem impressive. They are the only ones you have—we all take small, hesitant steps at the beginning. But if you possess the desire and the commitment, rest assured that you will, in time, proceed by strides.

NOTES

Epigraphs on page vii: Quotation from Giorgio de Chirico in Werner Spies, *Max Ernst Collages* (New York: Harry N. Abrams, 1988), p. 29. Quotation from Hans Hoffman in Mrs. Charles W. Hawthorne, *Hawthorne on Painting* (New York: Dover Publications, 1960), p. viii.

INTRODUCTION

1. This poem was inscribed by E. H. Gombrich in my copy of his classic art history text, *The Story of Art.*
2. Rollo May, *The Courage to Create* (New York: W. W. Norton & Co., 1975), p. 93.
3. Roxana Robinson, *Georgia O'Keeffe* (New York: Harper & Co., 1989), p. 392.
4. Vincent Van Gogh, *The Complete Letters of Vincent Van Gogh*, vol. 2 (Greenwich, Conn.: New York Graphic Society, 1959), p. 320.
5. Linda Chase, *Ralph Goings* (New York: Harry N. Abrams, 1982), p. 18.

CHAPTER I. ART FROM ART

1. Hubert Wellington, ed., *The Journal of Eugène Delacroix* (Ithaca: Cornell University Press, 1880), p. 378.
2. Robert Henri, *The Art Spirit* (New York: Harper & Row, 1984), p. 93.
3. Quoted in Katharine Kuh, *The Artist's Voice* (New York: Harper & Row, 1962).
4. Natalie Goldberg, *Writing Down the Bones* (Boston: Shambhala Publications, 1986), p. 79.
5. Quoted in James L. Enyeart, *Jerry N. Uelsmann* (New York: Little, Brown, 1982), p. 17.
6. Leo Steinberg, introduction to Jean Lipman and Richard Marshall, *Art about Art* (New York: E. P. Dutton, 1978), p. 9.

Notes

7. Quoted in Leo Steinberg, *Other Criteria* (New York: Oxford University Press, 1972), p. 59.

8. Wayne Thiebaud, "Scrambling Around with Ordinary Problems," *ARTnews*, February 1978, p. 84.

9. Meyer Schapiro, *Modern Art* (New York: George Braziller, 1982), p. 186.

10. Henri, *The Art Spirit*, p. 126.

11. Quoted in Robinson, *Georgia O'Keeffe*, p. 95.

12. Anne Truitt, *Daybook* (New York: Penguin, 1982), p. 120.

CHAPTER 2. OTHER POPULAR SOURCES

1. Van Gogh, *The Complete Letters*, vol. 1, p. 235.

2. Quoted in Alexander Lieberman, *The Artist in His Studio* (New York: Random House, 1988), p. 278.

3. Quoted in Wellington, *The Journal of Eugène Delacroix*, p. 386.

4. Jacques Lipchitz with A. A. Arnason, *My Life in Sculpture* (New York: Viking Press, 1972), p. 40.

5. Leon Battista Alberti, *On Painting*, trans. John R. Spencer (New Haven: Yale University Press, 1966), p. 94.

6. Vincent Van Gogh, *Dear Theo*, ed. Irving Stone (Garden City, N.Y.: Doubleday, 1950 [1937]), p. 536–37.

7. Wayne Thiebaud, "Scrambling Around," p. 86.

8. Conversation with Howard Fussiner, 26 April 1991.

9. Quoted in John Ashberry and Kenworth Moffett, *Fairfield Porter* (Boston: Museum of Fine Arts, 1982), p. 49.

CHAPTER 3. WORKING

1. Conversation with Michael Mazur, 24 April 1991.

2. Quoted in Elizabeth Alexander, "The Magic of the Commonplace," *New York Times*, 24 March 1991.

3. Van Gogh, *Dear Theo*, p. 19.

4. Quoted in Protter, *Painters on Painting*, p. 152.

Notes

5. John Barth, "Romancing the Muse: Just Wait and She'll Come Sidling Up," *New York Times Book Review*, 20 January 1991, p. 3.

6. Quoted in Ernst Gombrich, *Norm and Form* (London: Phaidon, 1966), p. 129.

7. Van Gogh, *Dear Theo*, p. 545.

8. Quoted in David Sylvester, *The Brutality of Fact* (New York: Thames & Hudson, 1988), p. 156.

9. Quoted in Ellen Johnson, *American Artists on Art from 1940–1980* (New York: Harper & Row, 1982), p. 42.

10. Larry Rivers with Carol Brightman, *Drawings and Digressions* (New York: Clarkson & Potter, 1979), p. 190.

11. Quoted in Dore Ashton, ed., *Twentieth-Century Artists on Art* (New York: Pantheon Books, 1985), p. 101.

12. Quoted ibid., p. 202.

13. Quoted in Calvin Tomkins, *The World of Marcel Duchamp 1887–* , pp. 8–9.

14. Quoted in Enycart, *Jerry N. Uelsmann*, p. 13.

15. Presumably the name comes from a joke about two men on a train. One asks the other what's in his package. "A MacGuffin" is the reply. "What's a MacGuffin?" asks the first. "It's for trapping lions in the Scottish Highlands." "But there are no lions in the Scottish Highlands." "Well, then, that's no MacGuffin." I thank Janet Fish for directing me to the article in the *New York Times* by Lorrie Moore on 10 March 1991 from which this story is quoted.

CHAPTER 4. OVERCOMING DIFFICULTIES

1. Steve Tourre, National Public Radio, 9 February 1990.

2. Quoted in Robinson, *Georgia O'Keeffe*, p. 267.

3. In Denise Levertov, *Collected Earlier Poems 1940–1969* (New York: New Directions, 1979), p. 84.

4. Quoted in Kojiro Tomita, *Day and Night in the Four Seasons* (Boston: Museum of Fine Arts, 1957).

5. Ben Shahn, *The Shape of Content* (Cambridge: Harvard University Press, 1957), p. 35.

Notes

6. Quoted in Carla Mathes Woodward and Franklin W. Robinson, eds., *A Handbook of the Museum of Art / Rhode Island School of Design* (Providence: Rhode Island School of Design, 1985), p. 220.

7. Quoted in Karen Tsujimoto, *Wayne Thiebaud* (San Francisco: San Francisco Museum of Modern Art, 1989), p. 39.

8. Quoted in Robert Rosenblum, *Modern Painting and the Northern Romantic Tradition* (New York: Harper and Row, 1975), p. 215.

9. Quoted in Ashton, *Twentieth-Century Artists on Art*, p. 200.

10. *New York Times*, 15 December 1991, section 2, p. 38.

11. Wellington, *The Journal of Eugène Delacroix*, pp. 401, 519.

12. Alberti, *On Painting*, p. 98.

13. Quoted in Kuh, *The Artist's Voice*, p. 13.

14. Quoted in Robert Doty, ed., *Jane Freilicher Paintings* (New York: Taplinger, for the Currier Gallery of Art, 1986), p. 50.

15. Quoted in Herschel Chipp, *Theories of Modern Art* (Berkeley: University of California Press, 1968), p. 621.

16. Talk with Garth Evans, 7 April 1991.

17. Quoted in Protter. *Painters on Painting*, p. 202.

18. Annie Dillard, *The Writing Life* (New York: Harper Collins, 1989) pp. 56–57.

19. Alberti, *On Painting*, p. 83.

20. Quoted in Elizabeth Alexander, "The Magic of the Commonplace," *New York Times Book Review*, 24 March 1991, p. 36.

21. Quoted in Protter, *Painters on Painting*, p. 139.

22. Conversation with Andrew Forge, 6 February 1991.

23. Quoted in Gombrich, *Norm and Form*, p. 61.

24. Quoted in Stephanie Terenzio, *Motherwell and Black* (Storrs: William Benton Museum of Art, 1980), p. 143.

25. Quoted in Kuh, *The Artist's Voice*, p. 156.

26. I am indebted to Eve Ingalls, who offered these particular suggestions during a conversation on 16 May 1991.

Notes

CHAPTER 5. GETTING STARTED FIGURATIVELY

1. Quoted in Deborah Solomon, "Celebrating Paint," *New York Times Magazine*, 31 March 1991, p. 40.
2. Audrey Flack, *Audrey Flack on Painting* (New York: Harry N. Abrams, 1981), p. 22.
3. Quoted in Terenzio, *Motherwell and Black*, p. 128.
4. Alberti, *On Painting*, p. 96.
5. Quoted in Ashberry and Moffett, *Fairfield Porter*, p. 57.
6. Quoted in Ashton, *Twentieth-Century Artists on Art*, p. 6.
7. Rainer Maria Rilke, *Letters to a Young Poet* (New York: Random House, 1984), p. 7.
8. Anne Truitt, *Daybook*, p. 178.

CHAPTER 5. A FEW FINAL THOUGHTS

1. Quoted in Rollo May, *The Courage to Create* (New York: W. W. Norton, 1975), p. 65.